OPEN YOUR STUDIO

Nine Steps To A Successful Art Event

By Melinda Cootsona

RedDot Press| Phoenix, AZ

Dedication

To all of my students who have taught me so much, and who are the spark that ignited this book.

Acknowledgments

To my husband, Marcus, who is a much better writer than I, and who has supported me with endless patience and encouragement since I was fifteen. To my parents, who must be getting a kick out of this in heaven. To MJ, for keeping me young and hip. To my artist family, Bill, Linda and Fred, you are each an inspiration – when is our next lunch? To Margi and Deborah, my original Open Studio mates. And a huge thank you to Jason Horejs for his creativity in promoting and educating artists.

Contents

Introduction

I am an artist and painting instructor living in Silicon Valley. Over the last 11 years I have hosted over a dozen Open Studios. My very first Open Studio grossed over $10,000, and since then I have hosted several grossing over $20,000. I have weathered the ups and downs of the economy by using various marketing ideas to keep clients coming back. Over the years I have been asked by students and artist friends to consult with them on the details that go into preparing and hosting an Open Studio. As these requests began to multiply, I realized the need for this information to be available for artists everywhere.

In this book I will review in detail the steps to take to create a fun and successful Open Studio event. First I'll help you decide if you are ready to participate. Then we'll discuss key concepts for attracting the most visitors to your studio. I also devote a whole chapter to pricing your art. Deciding on a value for your art is typically one of the most difficult tasks for an artist. I'll show you a foolproof method. I even discuss

how to *increase* your prices in a way your clients will welcome. Displaying your work and creating a "gallery atmosphere" and a "gallery-like reception" are also covered. Solid marketing techniques along with basic, and very artist-friendly, business concepts are reviewed to empower you to further your career.

This book is a step-by-step guide written to encourage artists to participate in Open Studios. This event is a wonderful way to begin and augment your artistic career. I hope this manual provides new artists with the confidence to participate, and experienced artists the guidance to increase sales and attendance.

Community Open Studio

San Francisco Open Studios, run by a nonprofit called ArtSpan, is the oldest and largest program in the country. More than 900 artists participate each year! The majority of community organized Open Studios throughout the country, however, are much smaller. I refer to these city-wide or county-wide events as "Community Open Studios." A "Community Open Studio" is an event planned by a group of artists (which can be a nonprofit organization) in a county or city; dates are selected and the participating artists agree to "open their studios" to the public. These events can be open to any artist who wants to participate for a fee, or they can be juried

events. In the latter case, artists submit their work to a committee who then selects the artists to be included in the event.

If the Open Studio in your area is a juried event, please don't be afraid to submit your work. Make sure that the images of your work are well photographed, and that only the work itself is showing. (No people holding it or feet in the image. That happens. Really.)

And PLEASE do not digitally enhance the photograph of your original. It's not a good habit to get into, nor is it honest. In a juried show you could be eliminated. And, if you don't get accepted the first time you apply—try, try again! Continue to work at your art and submit it again next year.

In either case, a catalogue is typically produced containing the artists' names, contact information, a photo of their work and a map to each site. The fees charged help to cover advertising, the catalogue, signage, etc. Community Open Studios usually occur on Saturdays and Sundays from about 11 am to 5 pm. The dates are designated by area (typically by county, or designated areas in a large city), and you can often participate in more than one weekend, which I'd strongly recommend. If you are going to all this trouble, get the most out of it!

Private Open Studio

A Private Open Studio is one that you can host anytime, whether by yourself or with other artists. Frequently artists

who live or work together in the same building will hold a Private Open Studio. Of course, you will do all of the advertising and marketing, but once you begin to develop a solid mailing list and a group of collectors, a Private Open Studio can be a very worthwhile and lucrative event, and something you should seriously consider.

I recommend hosting a Private Open Studio over a full weekend. I typically hold a reception on Saturday night, Similar hours to Community Open Studios seem to work well: 11 am to 5 pm or the equivalent. The reception timing works well from 6 pm to 9 pm. These hours work well in my community, but it's perfectly fine if your hours vary. I go into further detail about the reception in Step 7. It is an invaluable opportunity to get to know your patrons and develop relationships with potential clients.

Why Do You Want To Participate?

There are many reasons to participate in Open Studios, and you may want to have some idea of why *you* want to get involved before you commit. Why do you want to show your work?

Some possible reasons are:

• Input from the public

• Getting rid of inventory

• And, of course, selling your work and making some money!

If you are feeling nervous about participating in an Open Studio event, you are not alone. At every workshop I've given, there are participants who admit to being apprehensive about Open Studios. I want to reassure you, that although hosting the event is a lot of work, it is extremely rewarding. It may take some time to build a list of clientele, but the validation of your work is well worth the effort. You will receive feedback from the public, and almost always in a very supportive way. It is rare for anyone to offer harsh criticism about your work while they are either in your home, or in your studio space. And when people purchase your work, it's rewarding to know that you are indeed on the right track and that your work will sell. Open Studios can also be a transition to becoming a full-time artist.

One of the things that makes Open Studios special and very different from the experience of purchasing art in a gallery, is the interaction of the public directly with the artist. Having direct access to an artist, together with their work, is not an everyday occurrence, and is very exciting to many people. From the artist's viewpoint, this proximity to a patron is an important opportunity as well. This is your chance to both educate the client about your work, and to develop a connection with them. (I'll discuss this more in Step 9.)

Typically most artists have toured other artists' Open Studios before participating in their own. If you have not done this, I

would strongly recommend that you do. You should go to as many studios as possible, including ones by artists not showing in your particular medium. Take note of what you like and dislike about each studio. By this I don't mean the art itself; rather, the set up, how the art is displayed, the lighting, and most importantly: notice the artists themselves. Are they friendly, happy, talkative? Or shy and introverted? In other words, are they helping to promote their work, and are they giving clients a reason to buy their art? You should also play close attention to their pricing as this will affect your decisions about your own pricing (much more on this later).

When you do decide to participate, be sure to sign up early. Registration can sometimes be required as much as five or six months before the actual event.

Create What Inspires You

A word on subject matter: I feel very strongly that we, as artists, need to create what we are driven to create.

Whenever I have created a painting just for me with no intention of selling the work, it never fails to become the one piece that everyone wants to purchase. Whenever I have painted something specifically to "sell" at Open Studios, that piece sits on the wall and eventually gets painted over.

That being said, we need to be realistic about what the "general public" wants to put in their homes, or possibly in their

offices. If you are creating pieces that are extremely esoteric, "edgy," or experimental, you may not make a lot of sales at your event. HOWEVER, this does not mean that there is not an audience for your art! It may just mean that the typical Open Studio audience in your area may not be *your* audience. You will need to be realistic in your expectations, and sometimes the only way to do this is to participate in Open Studios and receive feedback from your visitors.

So, you have your original art and have decided to participate....

Let's get started!

Step One
Where Will You Host Your Event?

Your Studio Or Theirs

There are actually several options here, depending on how and where you create your art:

• Your Studio Away From Home

If your studio is located away from home, you may be amongst fellow artists. This is great as more artists will help draw more visitors to your site. Or you may simply have a studio away from your home, by yourself.

• Your Home/Studio

Your studio space may be at your home. Since my studio is also my garage, I have always hosted my Open Studio at my home. In our area, Open Studios is typically held in May. Guests can spill out into the garden and not necessarily enter

the house, which is a nice option. If you do host the event at your home, be sure to watch which doors are open and to put away any valuables. If your dogs are a potential problem, consider loaning them out. You may also want to check with your homeowner's insurance to make sure you are covered if anyone trips, or is injured, etc. At the very least, check your walkways and paths to make certain there are no tripping hazards.

Hosting an "Open Studio" implies that you have a studio, but not everyone has a studio that they want the public to come through. You may create your art at your kitchen table in a small apartment, for example. If you are one of these artists, don't let this stop you from participating.

• Shared Studio Space

If it is unrealistic for you to hold your own show at your home, check with your local Open Studios organization. Most of them will be happy to pair you with other artists who would like to share studio/garden space for this event.

Which leads me right into your second important decision...

Step Two
Group Show or Solo Exhibition?

One, Two, Three, Four, Or More?

The truth is that most people who visit Open Studios tend to go to those with multiple artists. If this is your first event and you do not have a "following" or strong mailing list (we'll talk about that later), I highly recommend that you participate with other artists, whether at your location or theirs.

Also, if you have hosted Open Studios in the past and have had poor attendance, this option may be your *number one step in increasing sales.* You can't sell your art unless people are there to buy it. Depending on the size of your space, this can mean inviting, or participating with, one or more artists. In my experience, two to four artists showing together works nicely, depending on the quantity of your work and the mediums exhibited. Other reasons to exhibit with multiple art-

ists include: shared costs, a larger client pool, and patrons who may stay longer to see all of the work.

If you have your studio in a building with other artists, sharing your own studio space may not be important. A multi-studio building should attract a good number of clients.

If you decide to show with other artists, you have some very important considerations:

1. It is important that *the quality of the work is relatively consistent* at your site. You need to look for other artists whose "experience level," for want of a better phrase, is similar to yours. The quality of the work should appear consistent to the viewer. This is something to consider, whether you are hosting the event or looking for a space to share. For example, you may have just begun to paint landscapes. If you feel that the person exhibiting with you is a vastly experienced landscape painter then you may not have confidence in our own work. Notice that I am specifically not saying that artists with more experience have "better" art. To some degree the perceived "quality" of all art is subjective. At the very least, emotional response to a piece can vary greatly from person to person. Work by a very inexperienced artist can be honest and authentic, whereas the work of a seasoned artist may be technically proficient but less engaging, for instance. The point is that no matter your experience level, you will have to decide for yourself if your work "shows well" with the other artists and vice versa.

2. Should you participate with artists in the same medium and style (oil/landscape, or watercolor/still lives, etc.)?

Pros:

• The show looks cohesive.

• The works complement each other.

• Buyers tend to go to sites that host their favorite mediums.

Cons:

• Too many landscapes (for example) to choose from can diffuse the work and confuse the buyer.

• If the work is too similar, you will be competing for the same clients.

• If the experience levels of the artists are too disparate, the buyers may again be confused, per my comments above.

The simplest choice to make, when possible, is to show with artists who work in different mediums. Over the years I have participated at different times with a mosaic artist, a printmaker, a woodworker and a jewelry designer. However, during my most recent Open Studio, I did exhibit with another oil painter. Our work complemented each other so naturally that we each benefited from the other's work and sales. It was much like a gallery, where more than one artist is showing.

If you decide to host an Open Studio event alone, I highly recommend having *at least* one friend or relative host along with you. It is very difficult to run an Open Studio completely by yourself. There are usually multiple guests with various questions and requests that may be too much for a lone individual to juggle. Also, a second host can keep an eye on your studio, your art, and your belongings if you are hosting the event at your home.

Step Three
Quality Of Work

Deciding What To Show

Obviously we all want our work to be "Gallery Quality," but don't let this prevent you from participating in Open Studios. This event is a perfect introduction into the world of "professional art." Displaying your work and getting feedback from your visitors is a great way to test the waters!

It's entirely possible that you have enough work that you may need some help deciding what to show. Line up all of your artwork and take a good objective look at it. Put your best/favorite pieces at one end and arrange them down to your least favorite. *Try to be objective in looking at the quality.* If you need help, have someone you trust help you out, perhaps a close friend, fellow artist, or a trusted instructor.

Show Only Your Best Work

Your work represents YOU. Make sure that it is something you will be proud of. It will hang on someone's wall and they will remember you when they see it. How much they like the art determines if they'll return. So, if you need to eliminate some of your pieces because you don't feel they are as strong, do it!

Be Cohesive

Make sure your own work "hangs" together (whatever medium you work in) as a nice presentation. To some degree, all of your work will hang together because it is yours. No one will paint, draw, or create exactly the same way you do and your individual style will show through. Even so, ask yourself, "Do any pieces look like they don't fit with the others?"

Quantity, How Many Pieces Should You Have?

Show between 25 and 30 pieces of varying sizes. You do not need to have this many to participate, and if you are with other artists, there may not even be room. I would suggest that you have at least 10 pieces of original artwork as a bare minimum.

If you have the room, a goal of 20 original pieces, minimum, is ideal. More than 30 originals will begin to confuse the buyer. Of course, if your work is small, you might very well have more than 30, and conversely, if your work consists of large pieces, 10 may be sufficient.

If you are a photographer or print maker or you create prints of your originals, the situation is different, as you may have multiples of one image or similar images. It is best, however, to remember to keep a cohesive look to your show and not display every print you have ever made.

Jewelry designers will typically have 30 pieces, and often much more. The mosaic artist that I have worked with usually displayed about 10 to 12 large pieces, and the woodworker had about a dozen jewelry boxes.

Portfolio Book

When space is limited or your art is not completely portable, have a nice book ready with photos of your other work. You can put this together simply; it does not need to be fancy. However, it should represent your work with good photos and an attractive presentation. This portfolio can also be a great calling card for commissioned work.

Older Work, Sketches and the Sale Box

Many of you may *not* be new to Open Studios and/or you may have been creating art for quite a while and have an abundance of inventory.

In visiting dozens of artists' Open Studios, I have noticed that there is often a "sale" corner or bargain section where artists try to get rid of older work, typically of lesser quality. Here's my view on Sale Boxes and Bargain Corners:

Don't do it! You are undercutting the value and sales of your current, top quality work.

Remember how this section began: SHOW ONLY YOUR BEST QUALITY WORK.

Here is how you handle the rest:

If you have been consistently selling your work over time and have older work that you have shown before, that you believe in, is good quality, and has not yet sold:

• Show it proudly and confidently with your other work, and *increase* the price of your current work. I know this sounds surprising, but this actually works! Your work is improving over time, you have decent sales along with some older inventory, so instead of discounting older works, make your work appear as though it is *increasing* in value (which it is) by *increasing the price of your new work*. I will go into "How To

Handle a Price Increase" in Step 5. (If you have participated in Open Studios in the past, be careful not to show your old work *repeatedly* as your clientele will recognize it and begin to wonder why it hasn't sold.)

You can also:

• Donate your work to a charity (there are lots of auctions and fundraisers that love art)

• Give to friends/relatives

Older Work that you now feel is outdated and doesn't represent your current abilities:

• Give to friend or relatives for Christmas, Hanukkah, Birthdays, etc.

• Of course you may want to keep your older work as well. Having a record of our journey as artists can be very informative. We can learn from our old pieces as well as see how much we've grown.

The point here is that you want to appear as professional as possible at all stages of your career. Many artists begin participating in Open Studios at early stages of their artistic endeavors (which is completely appropriate). Over time the quality of work often improves, and at each stage every artist should exhibit his or her best work to date.

Sketches or Studies

These can include ink drawings, quick sketches, plein air "studies," or quicker paintings. In other mediums, they may be smaller, less sophisticated or less detailed work, or possibly work from lesser materials. If these studies are of a quality that you feel could proudly hang on someone's wall, or could be placed in their home:

• Sell them at a lower price and *specifically call them out as sketches or studies.* This way they are separate "entities" from your originals, and they are just valued at a lower price, not discounted.

The Sale Box

O.K., by now my opinion is pretty clear…

I do not believe in creating a "sale area." *Your work is either worth the price or not.* If my paintings, which I feel are strong pieces, do not sell over time, I either donate them to charity or give them away to family and friends. (A sale area is not the same as a negotiated price. We'll discuss negotiating later.) I know this will be a controversial concept and that some experienced Open Studio artists will claim that they sell a lot of work from their "sale boxes." It's my belief, and I have seen success here repeatedly, that you would sell *more* current, full-priced work if you eliminate that sale box.

ANY WORK THAT YOU FEEL IS NOT UP TO YOUR CURRENT STANDARDS AS AN ARTIST SHOULD NOT BE SHOWN. DISCOUNTING YOUR WORK CHEAPENS IT. LITERALLY. And, it has the added side effect that collectors may think that their work is *decreasing* in value.

The Piece That You Currently Love

It frequently happens that we have an emotional attachment to one or more of our current works. We "really do not want to sell this one." You know this feeling. If you are attached to one or more of your works, I **strongly recommend that you hold onto those pieces**. I believe that if we don't want to sell something, it is because we still have something to learn from that piece. We are still interacting with it and it with us. If we sell it too soon, we lose the energy and information that the piece is still offering. Typically, there will come day when you look at the work and think, "Okay, fine, I'll sell that now," and the emotional attachment is gone. Until that time, keep it! Emotional attachment will cloud your view of pricing, which just so happens to be our next "step."

Step Four
How Do You Put A Value On Your Art?

Not Only Is Painting An Art, But Pricing Is An Art

For many artists, I know that your art is like your children, your offspring, your babies. For some it is more of a craft, but for others it is distinctly personal. Whichever description fits you, when it comes to pricing: The more removed you can be from your art the better. Easier said than done, of course, but while pricing your work; your goal is to separate yourself from your art. After all, you are ready for your "children" to now go out into the world and live with someone else or you wouldn't be participating in Open Studios!

Getting the right price for your art is a big key to your sales, so take a deep breath and begin to look at your work objectively. You will need to begin by doing a bit of research in your area.

Research Your Peers

The easiest way to judge how to price your work is to look to your peers. It is best to look for work in your area. Don't price your work for Manhattan, New York if you live in Broken Bow, Nebraska and vice versa.

• Visit other Open Studios and see what work is similar to yours and what other artists are charging.

• Visit any Art Leagues in your area. Many of them have galleries featuring emerging artists. See what these artists are charging.

• Are there cafés, banks, or public spaces in your area where artists can show their work? Check them out and note their pricing.

• If you participate in classes, ask other artists whose work is similar to yours if they sell their art, and what they charge.

• An online search for work that is similar to yours can help as well.

• Co-op galleries are great places to find local emerging artists and to research prices. These galleries are funded by the artists themselves, who pay monthly fees to participate.

My Philosophy On Pricing

I have always priced my work slightly under my peers – not drastically under, but just slightly. Why?

• By doing so, I know that my work is definitely worth what I am asking for it.

• I feel very comfortable with the price, and that confidence shows when I host my Open Studios event.

• I have found this practice leads to less price negotiating because buyers can see the value to begin with. I, personally, seriously dislike negotiating on the price of my work.

I will also tell prospective buyers that my prices are a bit low in the market. A slightly lower price gives me room to easily increase my prices over time. This has the added benefit of collectors seeing their purchases increase in value; a good marketing tool that helps to increase repeat sales.

You need to feel comfortable with your asking price. However, you also need to be realistic. This is why you need to do your research. In order to sell a decent quantity of work, it is *key to price your work appropriately.* Truthfully, it is rare that I see artists underprice their work at Open Studios. (When it happens I always purchase a piece!) If you are very comfortable with negotiating, and have a clientele that expects this, I can see why you may need to price your work slightly higher.

I would be extremely cautious with this approach, however, as you never want to lower the prices of your work.

I have been asked in my workshops about the expectations of the typical Open Studio "customer." Do they want a bargain? Are they looking for "a deal," or "a find?" The simplest answer is, "yes." Some of your visitors will be looking for a "good deal." If you have a healthy attendance, there will be a variety of expectations, which breaks down into something like this:

• The person looking for "cheap/inexpensive" art, and who is fairly naive (or unknowledgeable) about quality and art in general. I have found these people to be a relatively small percentage.

• The person who is relatively knowledgeable and is looking for good art *first* and a good price *second*. This seems to be the vast majority of my visitors. (Bless them.)

• The first-time Open Studio visitor (at least to *your* studio) who doesn't know what to expect and is often thrilled at discovering your "new" art. This is a good 20% of my visitors. These visitors represent a wonderful opportunity. Grab these people, educate them, find out their interests and cultivate them as potential buyers.

• The person who is just looking; often other artists, and their friends. Sometimes these people end up buying something, or

tell their friends who then come and buy something. Retail principle number one: **Everyone is a potential client.**

So, you can see the logic for a new Open Studio participant to slightly underprice his/her work. Since many visitors are looking for at least a partial deal, they will be able to see that your work is easily worth what you are charging. Again, I don't discount, and my work is not ridiculously underpriced or cheap. It is *just reasonably and appropriately priced.*

How To Price Your Work – Ya gotta do a little math…

For the two-dimensional artists, once you have a general idea of where your work fits in your market, look at your body of work and *find the most common size of your work.* You are going to begin by pricing that size, and from now on:

• You will price all of your work in the same medium BY SIZE.

• You are not going to price your work emotionally or subjectively by your favorite pieces. This will only confuse your buyer. In my webinars, I conduct a poll at this point, and typically at least 75% of the participants report that they have priced their work emotionally at some point. So don't feel bad if you fall into this category.

"The Case Of The Unmade Bed Painting" (A true story)

I was visiting a gallery in a nameless town (let's just say it was near Pebble Beach, CA), and I found a series of paintings that I loved. The small images depicted unmade beds (a habit of mine), with tossed pillows and sheets. The paintings, *all relatively the same size, medium and quality,* were priced approximately as follows (this was a while ago, so the numbers aren't exact): $3500, $2500, $1100, and $900. I called over the gallery director and inquired about the pricing. He replied, "We have no control over what the artists charge for their work." We discussed this a bit and agreed that this disparity in pricing was unfortunate.

Here's how my brain worked:

Gee, the artist really loves this $3500 painting; he thinks it's terrific. He must not think this $900 bed is very good, and he must not like the $1100 one much either. If he doesn't like it, I'm not going to buy it. I don't want his second or third best painting! This was a pure case of emotional pricing at its worst. If *I'm* thinking these thoughts, imagine how confused a typical buyer is going to be!

How To Price By Size

Start with the piece that is your most common size and decide how much money you would like to charge for that size. For example, many of your pieces are 16" x 20," and you have

decided that $300 – $325 is an appropriate price for this size. Next, multiply the width of your painting by the height; in this case, 16" x 20," and you will get 320. This number is right in your ballpark of $300 – $350. Your painting is 320 square inches and you happen to want about $320 for it, so it turns out that you want $1 per square inch for your work. In this case your "multiplier" is one for one dollar. This example is pretty straightforward: Whatever your painting size, multiply the width by the height, and then multiply that number by one.

Don't freak out here when I talk about cost per square inch. I know it seems like you are reducing your artwork to a "product," BUT **actually you are just giving yourself a system to help you price your art.**

Next, find the square inches for your other sizes and see if your "multiplier" makes sense for them. Pricing with a $1 per square inch multiplier looks like this:

Artwork Size	Square Inches	Artwork Cost
10"w x 10"h	100	$100
12"w x 12"h	144	$144
11"w x 14"h	154	$154
18"w x 24"h	432	$432

Once you have determined the general range of your pricing, you just need to figure out your multiplier to get the approximate cost of each size painting. Let's look at some other multipliers.

At my first Open Studio, my multiplier was .7 (or 70 cents an inch). This is how that looks:

Artwork Size	Square Inches	x.7	Multiplier Result	What I Charged
9" x 12"	108		$75	$75
12" x 12"	144		$100	$100
11" x 14"	154		$107	$100
16" x 20"	320		$224	$225
36" x 36"	1296		$907	$900

I felt comfortable with these prices. I was a complete unknown, my quality was high, and I sold a lot of art. I sold several large paintings and quite a number of medium and small ones too.

I want to note here that I think that **having a variety of sizes and price points is a really important concept**. Depending

on your medium, it will be up to you to determine how to achieve this. Smaller works, reproductions, less expensive or simpler materials are all ways to develop multiple price points. Again, this is different from discounting your work. You are just offering a variety of options for many different types of buyers.

Did I say use your multiplier as a *Guide*??

Certain prices are psychologically better than others. Having had experience in retail for a number of years (selling lots of stuff other than paintings), I have found that certain prices "sell" better than others. So your multiplier should be a guide to where you want to end up. Sometimes you will adjust your artwork cost slightly higher, and other times slightly lower.

Basically, I keep my prices in multiples of 5. And I stick to increases of $25. I use the multiplier to get me close to my number and then adjust accordingly. This is something that feels right to me and has been successful for me. Again, you will need to decide what is appropriate based on your own circumstance.

Remember the use of the multiplier is a system to help YOU price your work. If you have a wide range of sizes from small to large, this multiplier may break down differently once you reach a certain size both on the large side and on the small side. Again, this will depend on your research. My prices have increased over time but I cannot charge the same per square

inch size for my larger work that I do for my smaller work. So let's look at a chart that shows this adjustment.

This is what my prices look like using a 4.9 multiplier:

Artwork Size	Square Inches	x 4.9	Multiplier Result	What I Charge
10" x 10"	100		490	$500
12" x 12"	144		705	$700
16" x 16"	256		1254	$1200
18" x 18"	324		1587	$1500
20" x 20"	400		1960	$1800
24" x 24"	576		2800	$2300

You can see that the multiplier result is different than what I charge. **The point is that this system is flexible.** It is meant to be a guideline to help find your pricing. Since I feel that it will be much easier for me to sell my 24 x 24's for $2300 instead of almost $3000, I begin to "bend" or adapt my pricing to fit what I see is appropriate. (By the way, when you look at the gallery work of many artists, you will see the same principle.) As long as your pricing makes some degree of sense with the scale of your work, and looks consistent, no client is going to measure your work and haggle about inches.

This concept definitely applies to smaller work too. It took me about seven years to feel comfortable painting a 6" x 6" painting (I started large), so I am well aware that smaller pieces can often "feel" more valuable to artists than larger ones. Based on the work involved in creating any painting, I decided several years ago that I wouldn't sell any piece for less than $300. You may want to choose a "bottom" number as well, so that all originals of a certain size or smaller are the same price.

For three-dimensional artists, the "charge by size" concept can still apply. For those of you who work with a craft, such as jewelry, woodworking, etc. you may have to use additional factors to decide pricing. Cost of materials will obviously affect your costs. I am also asked about "time." How do you charge for a work that took many hours to create? You can and should charge for an intricate or detailed piece, but you need to be able to explain your reasoning to a client. No matter what medium you work in, anything you can do to help educate a potential patron is helpful. Photos of the work in progress, close-up shots of details, even written hand-outs of your process. Again, this is your time to shine and share your expertise with the public. The more information you provide your attendees, the more likely they are to appreciate your work and make a purchase.

Sculptors, Photographers and Jewelers

Since I work in two dimensions, I am most familiar with pricing for this format. For more information on how artists price work in other mediums, I turned to Jason Horejs, the owner of Xanadu Gallery in Scottsdale, Arizona. He has written a terrific book called, *Starving To Successful: The Fine Artist's Guide To Getting Into Galleries And Selling More Art* (see: Recommended Reading). In it, he includes pricing recommendations for other mediums, and I have quoted these below:

• Sculptors: Take your casting costs, multiply by three or four, and set the result as your retail value.

• Photographers: Price by the size, factoring in the number of prints. The higher the edition, the lower the price per print.

• Fine Art Jewelers: Price by the cost of your materials times four. If you create intricately detailed work, you may also factor in your time.

So just to review these concepts:

• ALWAYS be consistent with your pricing, no matter what your medium.

• Never price a work according to your own emotional attachment to it. If you feel a piece is worth more because you

think it is "better" than your other work, you have two choices:

1. Hold it back. Don't sell it and keep it until your other work has caught up to its quality. Remember my point about the "piece that you currently love."

2. Bite the bullet and sell it in accordance with your other pricing.

Matching Your Gallery

I am assuming that those of you in galleries know not to undercut your gallery prices. This is a sure fire way to shoot yourself in the foot and lose gallery representation. Both are not recommended outcomes. I am not going to go into this area much as I will assume that you know the terms of contracts with your galleries. Just to complicate things, however, there will be Open Studio visitors who expect to find artists who will sell their work at essentially 50% off (gallery price minus commission). *Don't do it.* The price of your work should be the price of your work, regardless of who is selling it. Hold your price. Keep your integrity.

I'm also frequently asked, "What if my gallery is in a city that commands high prices and my Open Studio is in my small hometown? Can I charge "hometown prices?" This is a tough situation. The simple answer is "no." If you value your gallery relationship, you really should not undercut their prices. One

option, however, is to create pieces that fall into a different category than your gallery work. Similar to the "sketches or studies" idea, think about creating work in smaller sizes, prints, different materials, etc. This way your integrity remains intact, you don't risk alienating your gallery, and everyone remains happy.

Negotiating

Get ready: At some point, someone will want to negotiate on the price of your work. As artists, 99.9% of us would like to avoid this process. We would compare it to the delightful procedure of a colonoscopy. Unfortunately, for our own good, we must address both. Here are some tips on negotiating:

• Ask the client what price they feel is fair. Everyone's idea of a discount is different. Sometimes a little consideration on the price causes great joy and a sense of triumph for the buyer.

• Don't say yes to this first offer.

• If it's reasonable, split the difference between their offer and the original cost. With one or two attempts you should come to a number that you both agree on.

• If their offer is ridiculously low, apologize and say that you can't do that. Instead, offer a number that you can live with,

but not your lowest number. Again, a few attempts will hopefully bring you to a sale.

• It's important to sell the work for a price that "works for you" (I'm not recommending huge discounts here).

• If you trust the client, offer a payment plan (like layaway).

• Offer to not charge the client sales tax. In my area this is almost a 10% discount (note: *you* will still have to pay tax).

Negotiating is not my top skill set, but the tips above work for me. You will need to find your own comfort zone for discounting your work. Just remember, *a client who is negotiating wants to buy.* It's not an affront. It's an opening. Keep them talking, hold your ground in a convivial way, and work towards a middle ground that is agreeable for both of you.

Pricing And Frames

When deciding on the price of your work, you should be pricing just the art, not the art with the frame. You can imagine, for instance, a 6" x 6" watercolor that is matted and framed up to 20" x 20," alongside a 15" x 15" image framed up to the same 20" x 20." If both are priced the same, this may appear inconsistent.

If you are just beginning to frame your work, use simple, relatively inexpensive frames that do not detract from your art.

Keep in mind that the frames must not look cheap, as you do not want them to cheapen your art either. This concept is very important.

Different artists are going to have different framing requirements depending on their medium and subject matter. I am going to list several different options for how to charge for your frames. Keep in mind that the more you pay for your framing, the more necessary it will be for you to add these costs to your pricing.

Options For Charging For Your Frames

• Don't Charge For The Frame

I use relatively inexpensive frames, and I do not charge for them. The cost of my art is the cost of the art, not the cost of the art plus or minus a frame. This way, if someone wants to change a frame or select their own, there is no change to the cost of the art, and there is no negotiating about a frame. Plus I get to say that I am giving the client the frame for free!

• Small and Large

A pastel artist I know charges $100 for a small frame, and $200 for a large frame. Simple. Decide what your small and large sizes are according to your own frame costs, and adjust your "small" and large" prices accordingly.

• Charge for the Frame

Of course, you can also keep track of your framing costs and add them to your artwork price.

• Percentage Mark Up

Some artists mark up their frames by 20% and add the total to the price of the painting, essentially making a profit on the frame. I see this occurring more often with relatively unique and/or high-end frames and more expensive original art.

• No Frame

Not every piece of art needs a frame. "Gallery-edged" canvases have a contemporary look and many collectors prefer hanging these without a frame. It isn't even necessary to frame every painting regardless of the edge detail. Photographs or prints can be sold with a mat for patrons to frame later.

Framing Resources

Here are a few framing resources. Each includes many options for simple, elegant frames. There are a variety of prices represented.

Tara Materials

Excellent frames for the price. (Note: you do need a resale license to buy from them)
www.taramaterials.com

Franken Frames

A wide range of frames and prices.
Will make custom orders. Very reasonable.
www.frankenframes.com

AC Graphics (no website available)

All frames are custom made to your specs. Fast turn around.
Very reasonable. Great floater frames
(415) 456-0363
San Raphael, CA

Step Five
Handling A Price Increase

And Making People Happy

If you're an artist who has participated in a few Open Studios, or whose work has improved and you'd like to increase your prices but don't feel comfortable doing so, here's your answer. I'm going to tell you a way to increase your prices so that your collectors will actually love you for it!

Follow these simple steps:

1. Send out an invitation to any collector who has ever bought a piece of your work.

2. This invitation is to a Preview Party of your current show. In the invitation, thank the collectors for their support over the years, and explain that you are going to be having a price increase on your work. But here's the kicker: Tell them that because of their support in the past, they are going to be able

to preview your show and have the opportunity to purchase your new work at your old prices (before the increase). This opportunity will only be available at your Preview Party, or for a very limited time. It is important to limit the time of this offer. I recommend no more than three days.

3. All new open studio guests will be purchasing at your new prices. However, they don't know you've implemented a price increase.

4. The most important benefit of all is that your collectors will see that the value of your art is going up! This is one of the key concepts that will keep them coming back to your events and following your art career. Everyone likes to think that the investment they made is successful and increasing in value.

I will tell you in Step 7 how to host a reception, and I encourage you to make this a special event. When I host these gatherings, I make certain to express the fact that I am genuinely thankful for my patrons' support over the years. After all, I wouldn't be able to paint and do what I love without their generosity. I would encourage you to feel the same and, as I said, if you handle your price increases thoughtfully and treat your collectors respectfully, they will love you too!

Step Six
Displaying Your Work And Setting Up Your Studio

"People want to buy from a Successful Artist, NOT a Starving Artist." – Jack White

Looking Like A Gallery

From the moment your guests/clients walk into your studio, you want to convey that you are a professional artist. How your art is displayed and priced, and how you present yourself are all key to increasing your sales. To create the gallery experience, you want your space to look as much like a gallery as possible. This does not mean that you need a pristine studio space! People love to see how an artist works. Left over paint on walls and easels, clay residue on wheels and counters are all

signs of energetic creativity. The intention is to clean up your space as much as feasible and to display your work effectively.

We've already discussed your quantity of work in Step Three. It's also important to take care in how you hang and display your work. Avoid crowding or "overhanging" your pieces. Let there be some air between your works. Also consider grouping similar subject matter or bodies of work together.

Use Creative, Simple Displays

Artwork can be displayed in many different ways, not just on walls. The best, most flexible display that I have found for two-dimensional work can be assembled from items available at any lumber store. I use three hollow-core doors hinged together to form a "zigzag," double-sided wall/screen. This screen can be painted any color to enhance your art. It can be used indoors and out, and folded up to store. Since these doors are somewhat heavy, you may want to use pin hinges so that the doors can come apart for moving. If you are using them outside and there is wind, you should tie them to a trellis or other support to protect them from falling over.

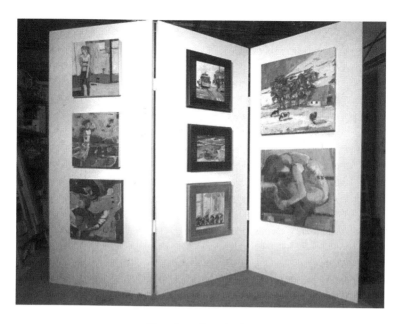

Easy three door display

I have used the same set of doors for over ten years. I use regular nails and hooks to hang the work, and the doors can be spackled and repainted easily. The doors also double as screens in my studio, and are a great place to hang paintings daily. If you are showing with multiple artists whose work needs hanging, this is a great solution. You can hang quite a lot of paintings on these panels; however, a little space, or "breathing room," between each work of art is ideal.

Easels And Moveable Art

Consider using your own working easel(s) to display your work. People love to see the "inner workings" of a studio. Small paintings on small easels are also a great sales tool for clients who say they have "run out of wall space." Let them know there are other ways of displaying art than on a wall. Easels can be placed on bookshelves, pianos, tables, etc., and this concept can also lead to the discussion with a client about how art should be a moveable/flexible part of their home. One sees art differently in different spaces, under varied lighting, and from new angles. Changing up the art in one's home can update a room and lead to discovering something new in a work of art.

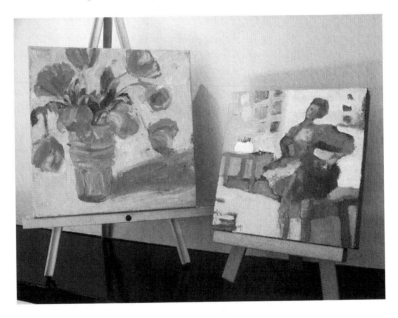

Use easels to display your art

Tables

If you have three-dimensional pieces, consider using tables with various height boxes on top. This can work for two-dimensional art on easels as well. Cover the boxes with white or black cloths (or whatever works with your art), and display your pieces on each of the different levels. If you have boxes that enhance your art, you don't have to cover them. The point is to bring visual stimulation to the viewer. The mosaic artist I show with uses burlap to cover her boxes and tables; a natural fiber that contrasts beautifully with her broken tiles, glass and other materials.

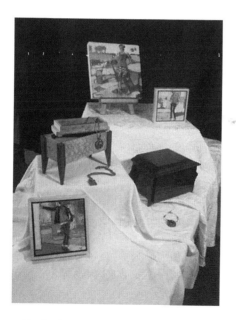

Creative table display (wood boxes courtesy of John Blackmore)

Sign-In Table – Capture those Contacts!

Have an area where your guests can sign in. I have mine right at the entry to my studio with the following items presented on top:

• A vase of fresh flowers

• Business cards

• Price lists

• Postcards from the current Open Studio and past events

• A Sign-In Guest Book that clearly states:

Name Email "Snail Mail" Address

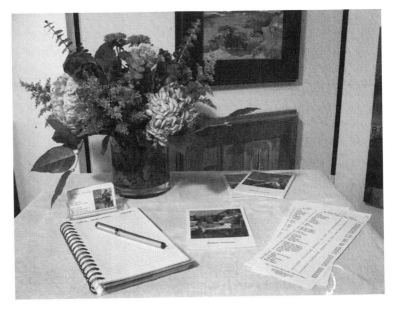

Sign in table

This is your big chance to begin collecting clients and their contact information. You are developing a mailing list of potential collectors. Each artist at an Open Studio should have their own sign-up book or sheet. It helps to know exactly who is interested in *your* work, and patrons are more likely to sign up for a specific artist's mailing. Obtaining their old fashioned mailing address is important and I'll tell you why shortly. *Everyone should sign this book.* If appropriate, make notes next to their name on the pieces they are interested in. You may want to contact them in the future when you create a similar piece or body of work.

A common question I hear in workshops is, "How do you get people to sign the mailing list?" Tell people exactly what signing the book means. You may send out newsletters, invitations, and special promotions. Let people know what they are signing up for. If you hold promotions or special events for people on your mailing list, this can be an added incentive. If they are interested, they'll sign. If not, then you really don't want them on your list anyway.

Artwork Name Tags and Price Lists

Remember, your goal is to keep a "gallery atmosphere." As a general rule, I feel strongly that whenever possible, the viewer should experience your art without a price glaring them in the face. *Keep your prices clear but discreet.*

For those of you who create Multiples/Reproductions/Prints, and have prints in plastic sleeves in bins or racks, it's fine to put a small sticker with the price on the sleeve.

Jewelry Designers will most likely have the prices on individual pieces, or will group the pieces by similar pricing.

Ceramic/Glass artists and others whose work does not have a "name," will have the price on tags or stickers near the art. Also consider grouping the pieces by price when appropriate.

For both sculptors and those of you who have work hung on easels: *Keep the prices and the artwork name tags separate.* Going along with our "gallery concept," when possible, it is much nicer to look at artwork without dollar signs looking back at you.

Name Tags

Your artwork name tags should have the name and dimensions of the piece. If you work in different mediums or on different surfaces, include that information as well.

Winter Roses

12" x 12"

oil on canvas

If you show with other artists, you may want to have either your name or a numbering system on the tag to help clarify which art belongs to which artist.

One super easy way to create professional looking name tags is to print your information on store bought printable and perforated business cards. These are easily formatted on your computer; print them out as sheets and then separate the individual tags. Use blue painter's tape, doubled over on the back of the card, to attach your tags temporarily to any surface.

Price Lists

Print out a price list that includes the name, dimensions and cost of each piece. Also include your name and all contact information on the price list. People tend to take these lists home with them, and you should think of this as a marketing opportunity, like a business card. Include the date of the Open Studio on the price list. This will become a record of the work that you displayed as well as the price that you charged each year.

			Blue Summer	
	New Paintings by Jane Awesome Artist			
		May 2013		
Title	H	W	Medium	Price
Ocean Blue	12	9	Oil	$200
Beach Party	12	12	Oil	$250
Surf	12	16	Oil	$350

Email: JaneArtist@yahoo.net

Website: www.AwesomeArtist.com

710.222.4444

Mini Price List Example. You will have much more art listed!

Make LOTS of copies of the price list and distribute them around your studio. For those of you who have prices on the work, you may want to have a general price list available for people to take as a reminder of your work as well.

Food

At each workshop I am asked, "What food should I serve?" It is a good idea to have some food on hand to offer guests during Open Studios. However, don't feel like you need to "feed the neighborhood!" Some possibilities are:

A fruit platter

A cookie selection

A cheese and cracker plate

A pastry selection

Ice water with lemon or cucumber

Iced Tea

Coffee

You certainly do not need all of these, and your selections may vary depending on the time of year of your event. I do not serve wine during the day, and I have a small, but nicely presented offering of food.

Artist Demonstrations – Creating In Front Of The Public

The Silicon Valley Open Studios organization strongly encourages artists to demonstrate their process during Open Studios. Their belief is that "Artist Demos" are part of what make Open Studios special and different from purchasing art through a gallery. I cannot argue with that point; however, actively creating your art during this event can pose difficulties:

• You are distracted.

• It is difficult to determine if someone is interested in buying a piece of your art while you are focused on a demo.

• It is hard to "encourage a sale" while working.

• You cannot keep an eye on your house or studio while creating.

I actually think that, on the whole, Artist Demos are a plus, and a good publicity concept to draw people to your site. If you plan to hold a demonstration, just be certain to have help with your visitors. At least one other person should be available to help with questions, sales, and studio supervision. Many artists will absolutely not create in front of an "audience," and that is perfectly ok. You do not need to "demo."

Lighting

Lighting is important. You should consider how your work will look during the time of day it will be viewed. I have successfully used industrial work lights to supplement my studio light. These lights are available at most hardware stores, like Home Depot, Orchard Supply, etc. They are halogen and provide a great deal of warm light that nicely illuminates artwork. Use caution as these lights can become quite hot.

Ikea can also have some good, inexpensive choices, depending on your needs.

Signage

Cities have varying rules about posting signs, so you may want to double-check with your city. Open Studio organizations often produce signs for the Artists so that the public has a consistent visual cue to look for throughout the community when trying to find your site. Try to get your hands on as many of these signs as possible. You can also laminate these signs, which makes them rainproof and wind resistant. Keep these signs from year to year so that you have plenty to use. Be sure to post them at locations with high traffic, to direct the highest number of people to your site. Also have good, clear signage at your site to direct people into your studio. Consider balloons or other bright visual cues to get people's attention.

Step Seven
To Party Or Not To Party?

Hosting A Reception At Your Open Studios Event

I'm going to be very direct here and say that 75% of my Open Studio sales take place at my reception, or because of my reception. I believe that *The Party Is One Of The Keys To Your Success.* It is not essential for everyone, but you should seriously consider hosting a reception as part of your Open Studios event, particularly if you can answer "yes" to one or more of the following questions:

• Do you have an existing client list?

• Do you have friends who have inquired about buying your art or who are interested in art?

• Do you have business contacts who may be interested in you art, or in art in general?

- Does your significant other have contacts who may be interested in art?

- Do your relatives have friends who are interested in art?

You can often generate a nice energy at a party with people who are just interested in art, even if they don't purchase your work. Of course, you want some of them to be buyers, but a common interest in artistic styles can be a great conversation starter, and can potentially lead to sales.

If this is your first Open Studio as part of your community, and you have a very small mailing list and are planning on building your client list from new visitors, then it may make sense to forgo a Reception.

If you are hosting your own PRIVATE Open Studios and are not part of a community event, I believe this party is essential to your success. I truly believe that it will increase your sales and bring more people to your event, thus exposing more people to your work.

The Public and Your Studio

Depending on the location of your studio, it may or may not be appropriate to invite the general public to your reception. My studio is at my home and I do not include the general public as part of this event. People that I know, along with "screened" clients, receive a separate invitation to my recep-

tion in addition to my postcard announcement. This has the added benefit of making the event seem a bit more "special."

If your studio is in a more public building, or is part of a group of studios, this may not be necessary, and a public reception can be a great event.

How To Party

Create an atmosphere of success and celebration. Remember that you are really celebrating the fact that you just worked very hard completing a terrific body of work for this show!

When To Party

Open Studios are typically held on Saturday and Sunday. I usually hold my reception during the evening of Saturday (the first Saturday if I am participating for more than one weekend). For example, if Open Studios occurs between 11am and 5pm, my reception will be from 6pm to 9pm. There is no hard and fast rule about this. Your reception might be held during Open Studio hours, or on the Friday before. You will need to decide what times work best for you, and when you believe you can attract the most guests.

Have a Table of Nice Food/Appetizers

Now is the time to have a "good spread." Have the event catered, or buy nice platters from your neighborhood grocery store. Make the event as special as you can afford. The trick is to do this without personally doing much of the "food prep." In other words, delegate creatively. You will have enough work just getting your art and studio ready.

If appropriate, serve wine or beer. Take your cue from gallery openings that serve a bit of wine to their visitors. Have non-alcoholic beverages as well.

Get Help

You need to focus on answering any questions and talking with your guests. You can't be worried about replenishing the veggie platter! Round up any friends and/or relatives who can help. Invite friends who are good talkers and who can help generate excitement about your work. A chatty bartender/friend is a wonderful addition. He or she will be the second most important person after YOU!

Music

Remember to have music of your choosing in the background. Let it represent you and/or your work.

Slides

If you are computer savvy, have your computer going with a slideshow of your work. People love this and will often see a piece on the computer that they didn't notice in your "show."

Be Yourself

Look professional. This is the time to dress up and show your style in whatever way you feel comfortable. Put away the paint and clay-stained aprons and shoes. The reception is the time to celebrate your art!

Step Eight
Marketing 101

Getting People To Come To Your Open Studio

Community Open Studios typically produce maps and an artist directory with a photo of each artist's work. Many also have events to participate in, such as preview exhibits at public spaces. Some also host a Single Group Site where people can go and see an example of each artist's work, essentially previewing all of the Open Studios in one location. You should participate in as many of these events as you feel comfortable. You want as much exposure as possible.

Hopefully, you will get many visitors from these resources; however, it is not guaranteed. To get the highest number of visitors, you need to do a bit of work to market your event on your own. Obviously, if you are hosting a Private Open Studio then you will need to do all of your own marketing.

Name Your Show

This is not a requirement, but I have always found that it's a great marketing tool to "name your show." It gives a theme to your work, and sounds more like a gallery presentation, even if it is "New Work by Joe Artist." However, I think it's preferable to have a name that represents you and your work. It can be fun and playful, or dramatic; whatever reinforces your art. Some show titles I have used are: Water and Light; Dogs, Barns and Blooms; and Christmas Roses and Other Delights

Postcards and Invitations

Some Open Studio organizations will produce their own postcards, which you can purchase and mail out. If you are on a tight budget, this is an option. However, in order to maximize the amount of potential customers attending your event, I would recommend sending out some kind of personalized invitation. Let's go over several options for this:

"Snail Mail" Postcard

Let's start with your own good old-fashioned postcard sent by "snail mail." An actual, hand–held postcard may still be one of your very best marketing "tools." This is one reason why it is so important to collect a client's postal mailing address. People love to get these in the mail, and if the image is good,

they tend to keep the postcards over time. I've had collectors tell me that they have five postcards of mine on their refrigerator that they have kept over the years. They look at them every day. What could be a better marketing tool than this?

Timing and Information

At least one month before your event, print your postcards or cards announcing your Open Studio. You should select an image that is representative of your "body of work," and consider including your name on the front of your card. If you have multiple artists at your sight, you may want multiple images and then you can share the card cost. Just make sure that the images do not get too small on the card. I do believe, however, that your own individual card is ideal. At the time of the printing of this book, 250 postcards from FedEx Office (previously FedEx Kinkos) online printing cost $69.99, and 500 cost $109.99. Vista Print has offers for even less: 250 cards for $42.99. These postcards are worth every penny and they are the best marketing tool for your money. When selecting your options, I would recommend glossy stock. The "matte finish" at some of these printers is of poor quality.

On the back side of your card, include:

• Your name and the name of your show.

• The dates of your show and reception (if applicable). Often I print these in bold.

- The address of your event.

- Your return address.

- Your Website and any contact information that you want to share.

- Also include the name of the image(s) on the front of the card.

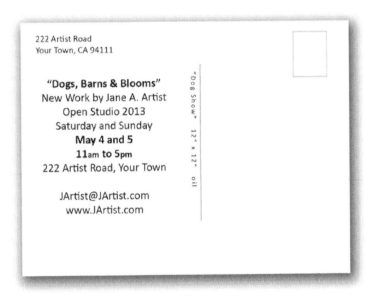

Mail your postcards about 2 ½ to 3 weeks before your event. If your event is near a holiday, such as Christmas, mail them three weeks in advance.

If you are on a tight budget, there are other options:

A Printed Invitation Without An Image

If you don't have computer skills, and cannot afford to print a postcard, a simple printed invitation to your event is a viable option. This invitation can be sent out to your mailing list. You can also create "flyers" with your information to be distributed at public spaces. Obviously this is not ideal, as an image will always capture someone's attention more than words. However, it is better than no invitation at all.

Email Invitation/Announcement

An email announcement is a good alternative to a postcard and even better when used IN ADDITION to the postcard as a reminder of your event. Include the same information as the standard postcard, as well as the photo of your work. If you send this out as your only announcement, I would send it out twice: once about 2 1/2 weeks before the event and again in reminder form about 5 days before the event. If you send it out *in addition* to your postcard, send it about 5 days before the event.

Post-Card Printing Resources

Here are just a handful of printers. There are many options in every city.

Modern Postcard
modernpostcard.com
- Allow extra time for this supplier.
- For extra $$, you can have a proof to review for color.

FedEx Office (Kinkos)
fedex.com
- You can use their online ordering or go to their actual locations. You can get a proof if you go to the store.

Vista Print
Vistaprint.com
- Great prices.

Paperless Post
paperlesspost.com
- A great resource for fun email invitations.

Just a note here...

Make sure to check with your printer on the quality of the image needed to create a successful print. You will need to **have a high quality photograph** to create a good postcard. Make sure your camera is set at the highest quality, or find a

professional photographer in your area to take a good photo. Some printers will also take a photo of your image for you.

I have never been 100% pleased with the color of any of my postcards, so be prepared to compromise a bit. As artists we want our work represented perfectly, but I have found that excellent color matching is quite difficult to achieve in practice.

Brainstorm For Patrons - Your Mailing List

Get the word out! You want to send your postcards out to as many potential buyers as possible. Developing a great mailing list is key to your business. It's time to brainstorm. Here are some ideas to start you thinking about who may be potential buyers for your art. I'm sure you can think of more. You'd be surprised at how many people are interested in art!

• Relatives and their friends

• Friends and their friends

• Teachers of your kids

• Parents of your kids' friends

• Workplace associates, past and present (when appropriate)

• Exercise or workout mates

• Classmates at any school you may attend

• Associates at any organizations or clubs

• Neighbors

Artists can be very protective of their mailing list as they should be. However, if you have artist friends, particularly in other mediums, they may have some clients they'll be willing to share. You can always ask.

Social Networking

Given their reach and impact, I can't leave out Social Networking such as Facebook, Twitter and Linked-in. Some of you may be more comfortable with these methods than others, and for those of you who use these platforms, go for it. Here are a few suggestions:

• Join your "Community Open Studios" Facebook page.

• Announce your event on Facebook and Twitter.

• Post links on Facebook to your website.

• Announce your Open Studio on your website and upload a map to your site if possible. (You may not want a map directing people to your home.)

More Ideas to Attract Visitors

Postcard Scatter

You will find that many of the businesses you frequent are very supportive of the arts, and are more than willing to let you leave your postcards on their cash-wrap desk, counter, or other appropriate display surface. These are just a few examples of locations. Ask friends and relatives if they have any suitable locations as well. You must always ask the business for permission to display your cards.

• Your Bank

• Hair Salon

• Favorite Boutique(s)

• Favorite Coffee Bar

• Library

• Gym

I have received dozens of clients from my hair salon, favorite boutique and nearby coffee house.

Postcard Share

Here's a great idea, particularly for those of you who may not be in the best possible location: When you get the catalogue for the Community Open Studios, look for two or three art-

ists who are closest to you. Contact them and ask if they are interested in exchanging postcards. You may even draw up (read: Google) a map that takes clients from each of your sites to the next; a mini-Open Studios map. Each artist can then encourage visitors to attend their "neighboring" artists' studios. If you have friends who are hosting Open Studios at other locations, consider placing a stack of each other's postcards at your individual sites as well.

Press

Local newspapers love to print stories about local artists. There are also many online "newspapers" that are easy to contact and, typically, love a good local story. Look up "Patch.com" and see if there is one in your area. Don't be afraid to contact your local paper and let them know what you are creating!

Step Nine
The Business Side Of Things

The Tax Man

Don't run screaming. It's not that bad. There are some very simple steps to turn your art sales into a business. Technically (and legally), you should have a resale license to sell your work. If you hold your Open Studios and find that you are pretty darned successful, you really must consider getting your license. I feel obligated to at least give you the information and you can decide how to handle your business. I won't spend too much time on this, but I want to give you the basics.

I also want to reassure you that the business side of art is very approachable and do-able. Though it seems overwhelming when you are not familiar with business terms and practices, once you understand the basic steps to set up a small business,

I think you can become confident in your ability to run an "art business."

Need another motivator? Once you declare your art sales income, you can write off supplies, museum memberships, art magazine subscriptions, and this book!

Resale License

If you are in California, the website to obtain your resale license is: www.boe.ca.gov. In other states, look up "State Board of Equalization" and you will find your resource. Each state has a different website name.

When you have a resale license, you will, most likely, send in sales tax from your art sales "quarterly," or four times a year. However, some artists only file once a year. If you have no sales, you don't send any money. You do, however fill out a form claiming zero sales. It can now all be done online and is really very simple. Really.

Business License

You may need a Business License once you have a Resale License. Again, it's really not too hard. This can depend on the city in which you live. A visit to your City Hall in person or online will get you an application. Fill it out accordingly and you should receive a license in the mail shortly thereafter; for

a fee of course. Fees seem to vary greatly by city. Gotta pay the man.

Income Tax

You will, of course, need to declare your art income on your federal income tax form. You will use a "Schedule C" form to list your income and deductions (see, that's not too hard). You will also need to declare your income on your state income tax form if applicable. Laws can vary from state to state, so I recommend consulting with your accountant if you have any questions.

The Fun Stuff – The Sale

The art is hung and labeled, the signs are posted, the price lists are printed, and visitors start arriving. This is not the time for the shy–artist–in–the–corner act. You need to interact with your "guests." Most people are genuinely interested in an artist's process, both literally as in, "*How'd* you do that?" and internally as in, "*Why'd* you do that?"

In my seminars I have found that many artists are shy about speaking with the public. If you have similar feelings, you are not alone. An artist friend who showed her beautiful etchings at my Open Studio was extremely shy. I would pull her out of her "corner" to interact with people who were fascinated by

her work. After a while she realized that most visitors knew nothing about the printing techniques she used. Eventually, it became quite easy for her to discuss her methods of working and her joy of the printing process.

Now is the time to talk about what we do. I find that the best "sales pitch" for me is simply talking about my work and informing a potential buyer on some part of the process. Educating the public about the merits of fine art and the benefits of purchasing an original piece of art over a "poster" is something that I feel very passionate about. It feels natural to me, much more so than the thought of "selling" my work or "closing" a sale. Hopefully, you feel excitement about your work as well. I would advise you to connect with what you feel most passionate about in your work and learn to communicate this to others on some level, even if what you feel most comfortable discussing is purely the technical aspects of your medium, which is perfectly appropriate. If you still find it difficult to speak with visitors, then consider having a friend or relative present to help communicate and explain your work if asked.

With luck, you've been speaking with your clients, answering questions about your art and generally sounding enthusiastic, and someone wants to buy your work. Now what?

Receipt Book

Everyone should take this simple step:

• Purchase a receipt book at your local stationery store.

• Write up each sale in your receipt book.

• Include the buyer's name and make sure you get their contact info.

• Ideally, the receipt should have your name on it as well. I stick simple mailing label stickers with my information at the top of my receipt pages. Again, the receipt is one more item the client takes home with your name on it.

• The receipt book also serves as a record of your sales tax.

Of course you may also print your receipts from your computer if you are comfortable with technology, but a simple store-bought receipt book works just fine. One way or another, make certain to have a record of the sale.

Red Dots

Make sure to purchase a package of "red dot stickers," and place one dot on the name tag next to your work when you make a sale. You may actually want to keep certain pieces for the duration of your show, and/or clients may not be ready to

take home your work immediately. It's great to show red dots next to sold art.

It's possible to use this as a marketing ploy as well. You may place red dots next to a painting or two that aren't technically sold to make it look as if you are doing business. Be aware that this can backfire, however. It's a strange retail phenomena, but customers will often focus on the work that has "already sold." Have a back-up plan. For instance, tell the client that the painting is on hold, but you'd be happy to sell it to them now.

Do You Take Visa?

Times have changed and with the advent of smart phones and iPads, there are amazing options available for merchants (that means you!). It is not necessary to take charge cards, and if you are just starting out, I don't recommend it. Cash and checks have always worked fine for me. If you don't trust someone, ask for cash, or hold the work until the check has cleared.

When you are ready to take cards, please research each option well. All companies will take a fee. Percentages can be based on the average cost of your sale. Some companies may ask for a time commitment (sign up for three years). *Use caution and good judgment before you commit.* It may be helpful to ask a fellow artist in your area if they are pleased with a specific

company. Below is a list of several companies that you can sign up with, enabling you to accept charge cards as payment:

- www.squareup.com

- www.intuit-gopayment.com

- www.merchantanywhere.com

- www.paypal.com

Your own bank may offer these services as well. When working with a bank, you typically need your resale number and business license.

Patrons, Your Most Important Resource

You've sold your art. You now officially have a patron. *Make absolutely certain to get their contact information.* This information will become a vital part of your business, your mailing list, your connections, and, for some artists, your resume. People who have already purchased your art are the most likely to purchase more.

Address Book

However you record your Contacts, make sure you update your Address Book after each Open Studio Event, adding your new clients and visitors.

Thank You Notes

It never hurts to send a nice thank you note as a follow up to a sale; particularly when it is a large sale, or one with multiple paintings. Again, you are connecting with your client and making the sale personal.

Photograph Your Event

Consider taking photos of your display and event. It's great to have a record of what you've accomplished, and the photos are fun to look back on over time to see how your work has changed.

After The Show

As a courtesy to your neighbors and city, remember to remove the signs you have posted in your neighborhood. You'll need that spot to post the signs for your next Open Studio!

Congratulations!

You've just produced your own successful Open Studio show. It's time to relax with a glass of champagne!

Conclusion

I realize that following the steps in this book requires you to combine art and "commerce." For some of you, this may be like combining oil and vinegar – they don't mix. Artists have struggled with this combination ever since the first work of art was sold. However, if you plan to make all or part of your living with your art, or even if nice people simply want to buy it, you'll need to decide how this part of the "recipe" works. Some of you may have been solely concentrating on the creative process, and here I have outlined steps to essentially begin a small business. I want to encourage you all that selling your own art can be done successfully without "selling out" or compromising your integrity. And, in fact, by thinking it through ahead of time, you'll protect the creative side of your work by being prepared with the commerce. Holding an Open Studio is a great way to begin this process slowly.

I have participated in both Community Open Studios, and have hosted my own Private Open Studios. I've had a fabulous time at each event, meeting new people, discussing art,

making sales and ultimately having my art validated by both the verbal and financial support of the people attending.

The other ingredient in a great salad dressing (if I may continue the metaphor) is an emulsifier: the substance that stabilizes the ingredients. For me that substance is passion and love. I'm passionate about my work and I love my patrons for supporting me so that I can continue to create. I sincerely hope that all of you can blend your own ingredients to find a successful balance of art and business.

Remember:

Always Paint and Create From The Heart.

Create what you want to create and what speaks to you.

People will see the passion in your work.

Have a fabulous, successful Open Studio!!

Recommended Reading

Good Books For Your Career:

Horejs, Jason. *Starving To Successful, The Fine Artist's Guide To Getting Into Galleries And Selling More Art.* Phoenix: Red Dot Press, 2009. www.xanadugallery.com.

Lang, Cay. *Taking The Leap, Building A Career as a Visual Artist.* San Francisco: Chronicle Books, 2006.

A Good Book For Your Artist-Self:

Roberts, Ian. *Creative Authenticity.* Fairfield: Atelier Saint–Luc Press, 2004.

Melinda Cootsona with Daiquiri and Toaster

Melinda Cootsona is a native of Northern California. She attended the California College of the Arts in Oakland where she received her BFA in Interior Architectural Design in 1981. She worked full-time in both the Interior and Graphic Design fields for over twelve years, designing "furniture systems to album covers." She also taught design for two years at the Academy of Art College in San Francisco. Melinda has been a painter for over 20 years, and has taught oil painting classes and workshops for twelve years.

"My goal is to bring out the "artist/creator" in every student; to guide each person through the process of painting to discover both the joy of creativity and his/her individual voice."

95

Contact Information

mlcstudios@comcast.net

I'd love to hear from you. Let me know of your stories and successes. Also, if you have any further questions, I'd be happy to help. Just give me a few days to answer my email!

Please join my mailing list for my email newsletter, which includes updates on shows and webinars, at www.melindacootsona.com.

Read my thoughts on art and creativity at my blog: www.painthappens.com.

I offer a workshop on the topics covered in this book to art groups across the nation. Is your group looking for an energizing, fun, informative event? Have your program director email me at mlcstudios@comcast.net today to schedule a workshop.